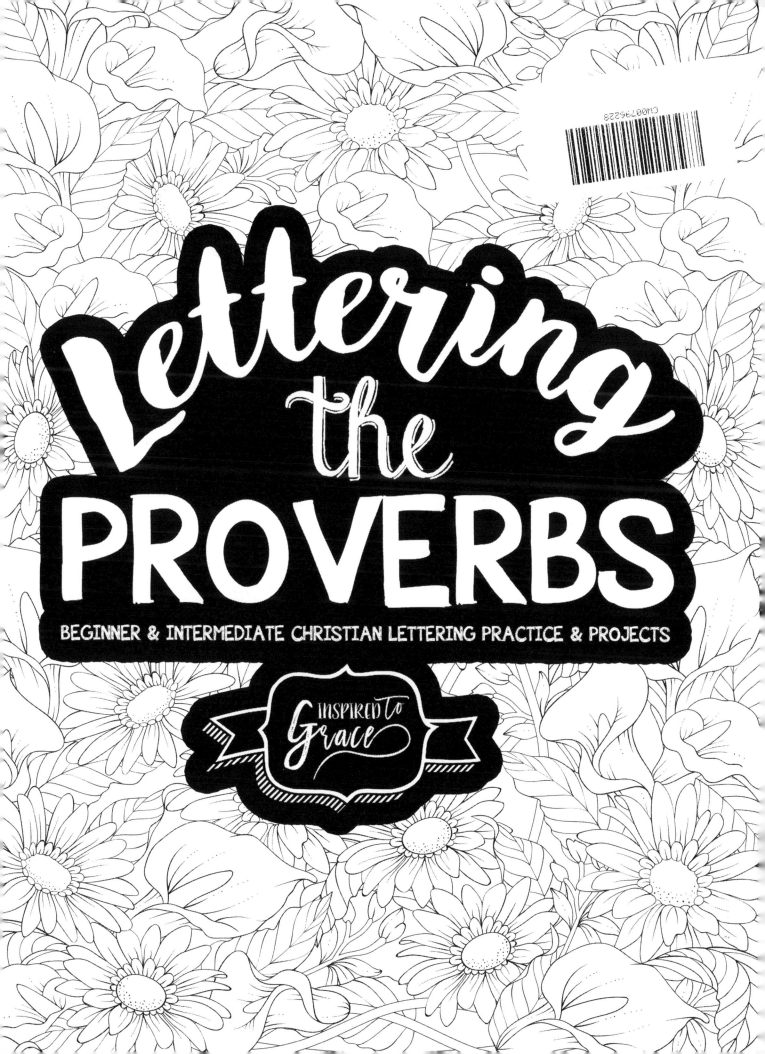

Lettering the PROVERBS

BEGINNER & INTERMEDIATE CHRISTIAN LETTERING PRACTICE & PROJECTS

Inspired to Grace

Welcome to Lettering the Proverbs!

THIS BOOK HAS 44 UNIQUE AND CREATIVE LETTERING PROJECTS FOR YOU TO ENJOY. THE PROJECTS VARY IN COMPLEXITY FROM BEGINNER TO INTERMEDIATE. WE RECOMMEND THAT YOU FLIP THROUGH THE BOOK UNTIL YOU SEE A VERSE OR A STYLE THAT SPEAKS TO YOU, AND START THERE. THERE IS NO RIGHT OR WRONG WAY TO ENJOY THIS BOOK.

LETTERING THE PROVERBS IS PRINTED ON 60-POUND BRIGHT WHITE STOCK WHICH ALLOWS US TO PROVIDE AN EXCELLENT VALUE TO OUR CUSTOMERS. IF YOU HAVE ISSUES WITH BLEEDING, OR IF YOU MAKE A MISTAKE AND WANT TO START OVER, YOUR PURCHASE INCLUDES A DOWNLOAD CODE WHICH WILL ALLOW YOU TO SIGN UP FOR OUR NEWSLETTER AND THEREBY ACCESS ALL THE LETTERING PROJECTS IN THIS BOOK AS PDF DOWNLOADS.

SIGN UP AT: WWW.INSPIREDTOGRACE.COM/LTPV

YOUR DOWNLOAD CODE: **LTPV363**

@inspiredtograce

Inspired to Grace

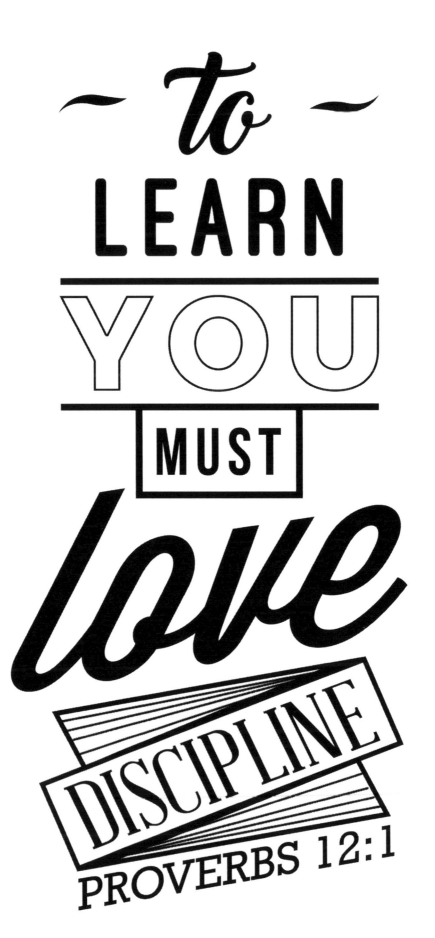

~ to LEARN YOU MUST love DISCIPLINE PROVERBS 12:1

LETTERING PROJECT 1

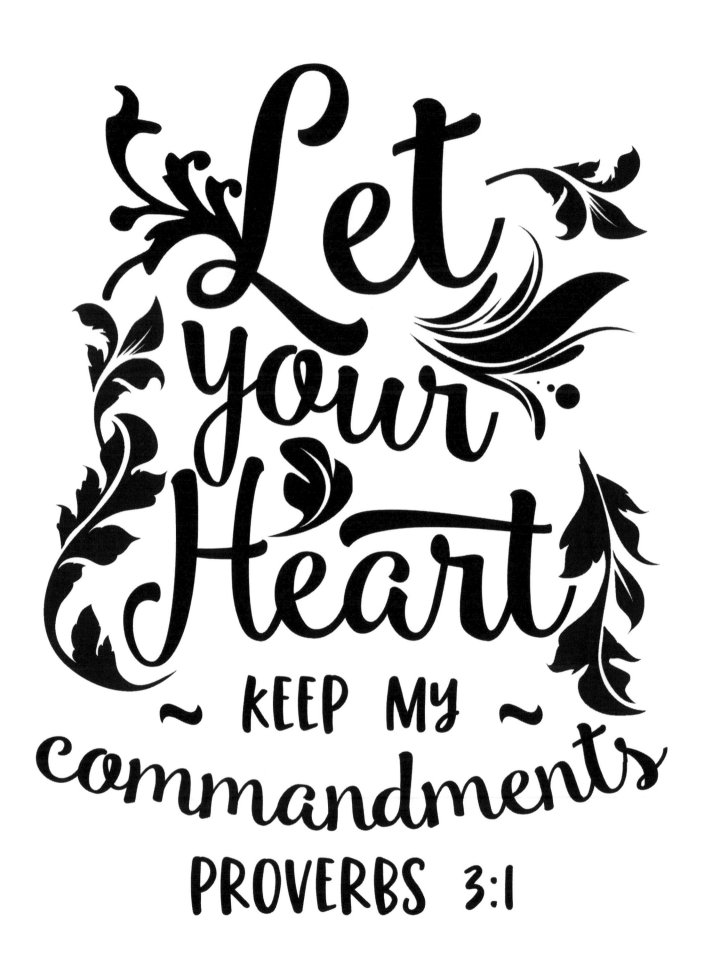

Let your Heart ~ KEEP MY ~ commandments PROVERBS 3:1

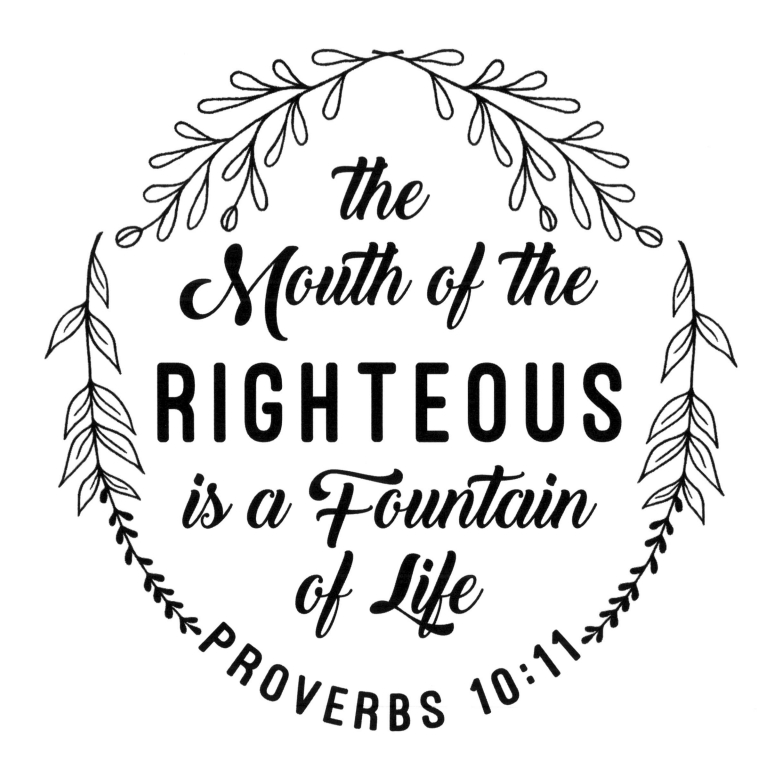

the
Mouth of the
RIGHTEOUS
is a Fountain
of Life
PROVERBS 10:11

Blessed

ARE THOSE WHO FIND

WISDOM

PROVERBS 3:13

ARE THOSE WHO FIND

Cry out for
INSIGHT
and ask for
UNDERSTANDING
PROVERBS 2:3

GODLINESS makes a Nation GREAT

PROVERBS 14:34

makes

GREAT

Whoever belittles Another lacks sense Proverbs 11:12

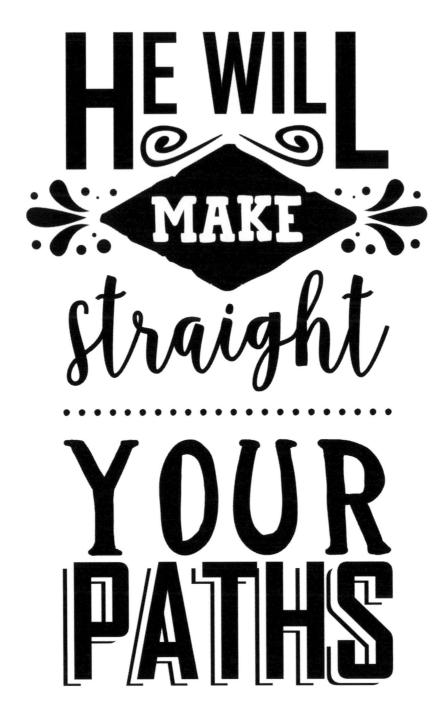

HE WILL MAKE straight YOUR PATHS

····· PROVERBS 3:6 ·····

· ·

· · · · · · · · · ·

You can make many PLANS but the LORD'S purpose will prevail

Proverbs 19:21

PLANS

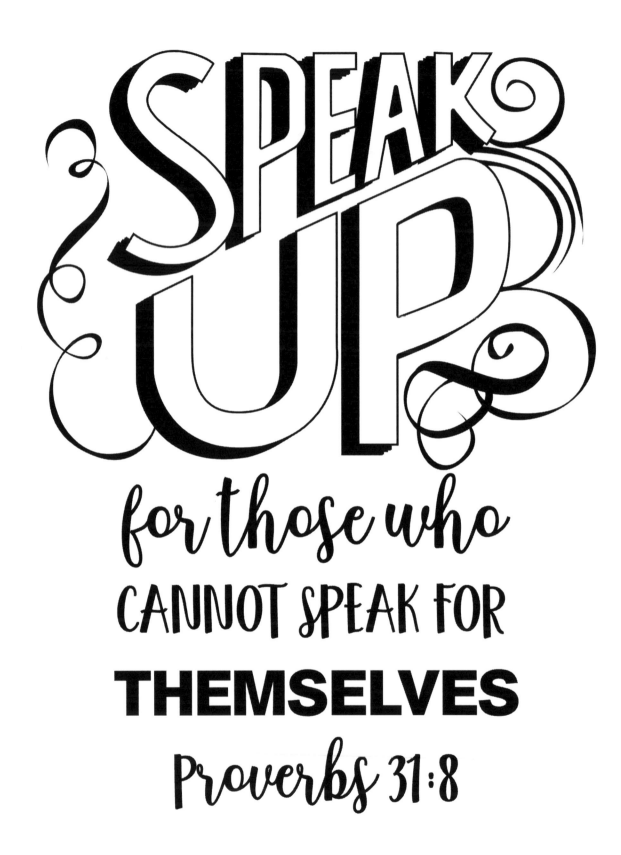

SPEAK UP for those who CANNOT SPEAK FOR THEMSELVES Proverbs 31:8

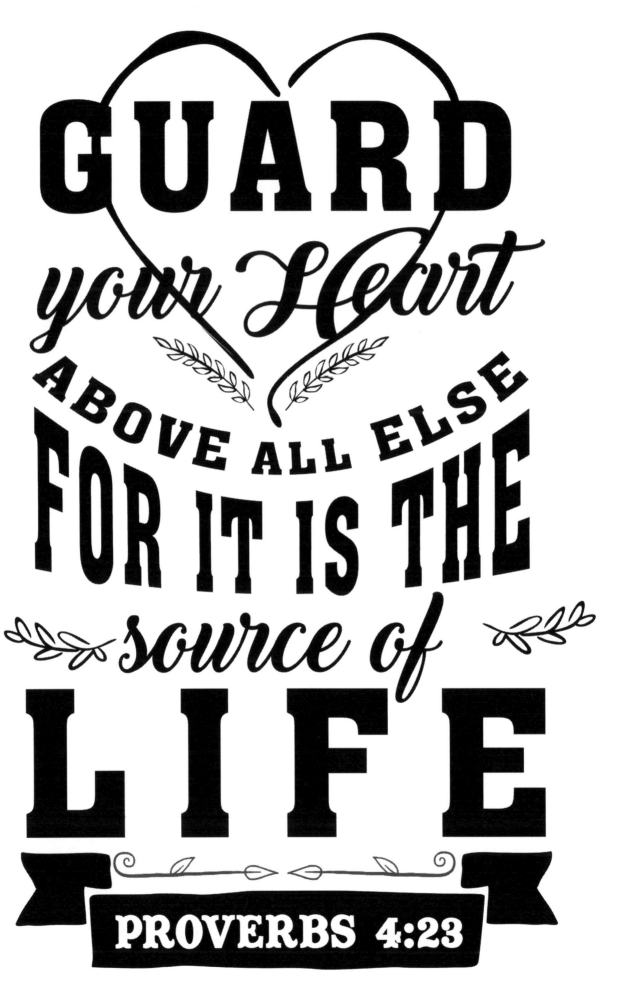

GUARD your Heart ABOVE ALL ELSE FOR IT IS THE source of LIFE

PROVERBS 4:23

LETTERING PROJECT 11

PROVERBS 4:23

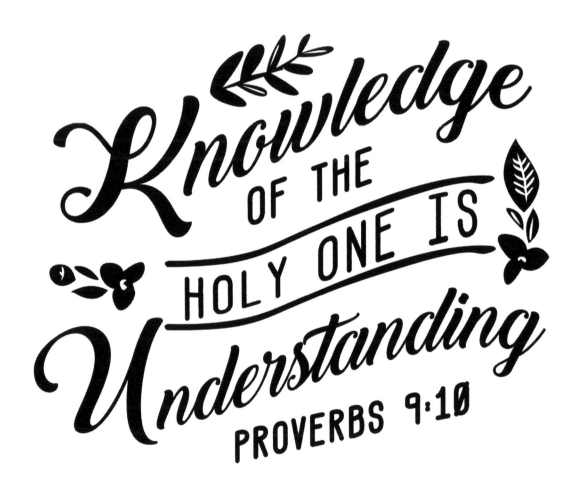

Knowledge OF THE HOLY ONE IS Understanding

PROVERBS 9:10

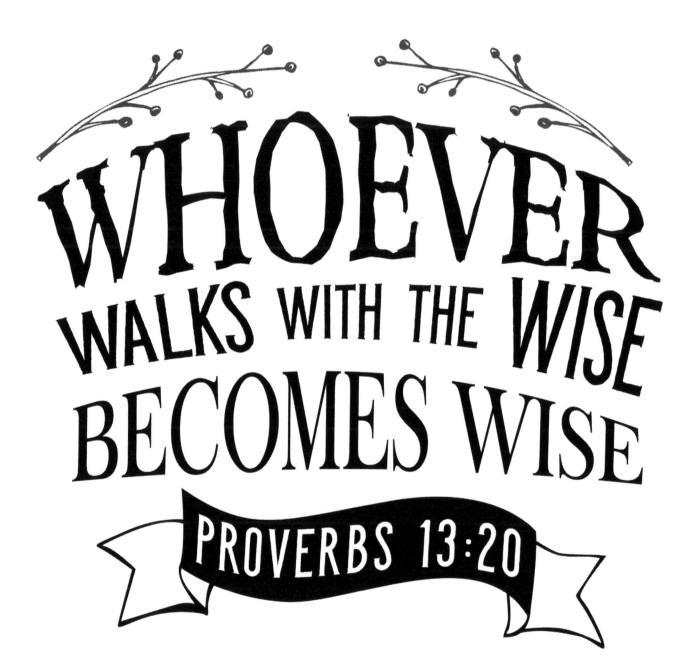

WHOEVER walks with the WISE BECOMES WISE

PROVERBS 13:20

PROVERBS 13:20

A Gentle Answer Turns Away Anger

Proverbs 15:1

ANGER

A man's heart plans his way but the LORD DETERMINES his steps

PROVERBS 16:9

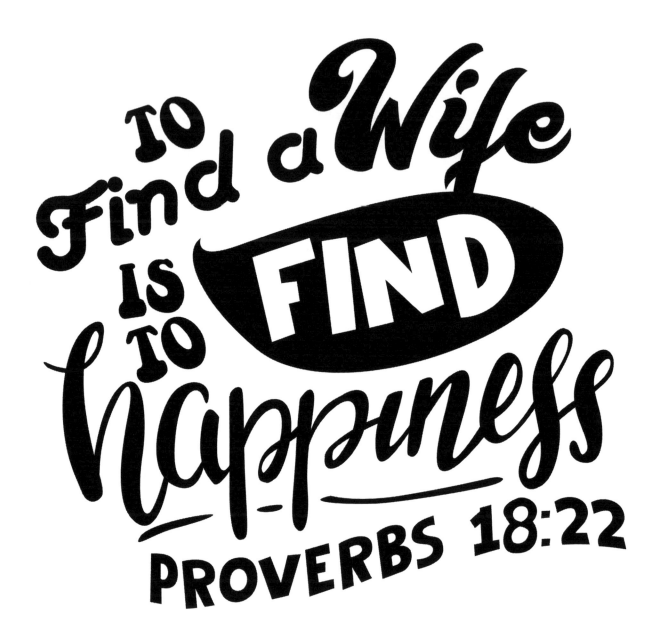

To Find a Wife is To FIND Happiness

PROVERBS 18:22

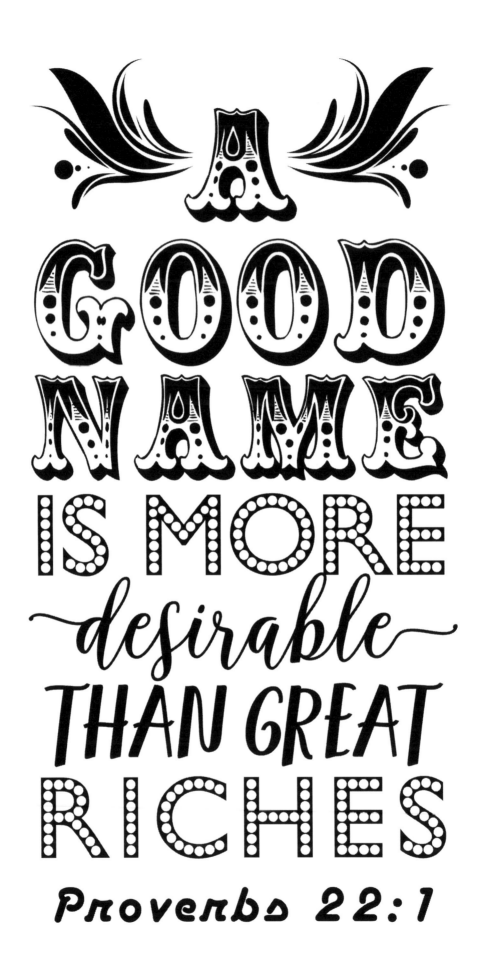

A GOOD NAME IS MORE *desirable* THAN GREAT RICHES

Proverbs 22:1

As iron sharpens

IRON

so one person sharpens

ANOTHER

PROVERBS 27:17

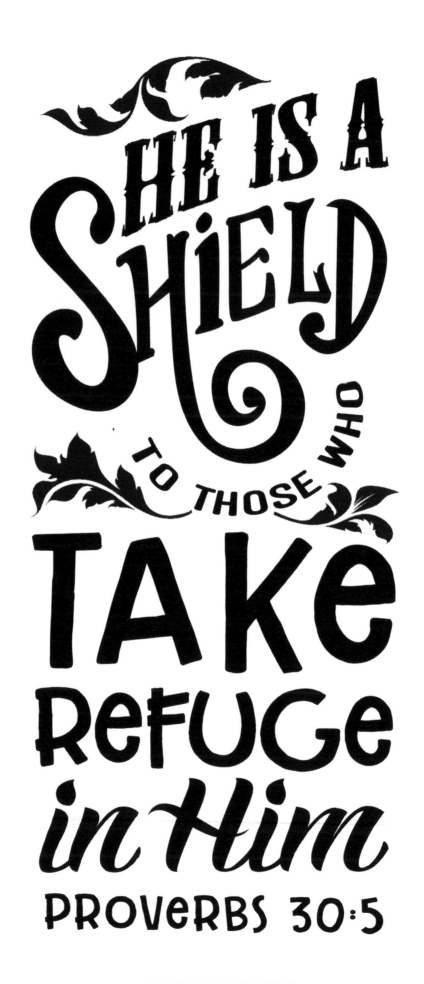

HE IS A SHIELD TO THOSE WHO TAKE REFUGE in Him

PROVERBS 30:5

Who
CAN FIND A
CAPABLE WIFE?
SHE
IS FAR MORE
precious
than
jewels

PROVERBS 31:10

LETTERING PROJECT 20

Who

jewels

Charm
IS DECEPTIVE and
Beauty FLEETING

PROVERBS 31:30

TRUST IN THE LORD WITH ALL YOUR HEART

PROVERBS 3:5

Lord

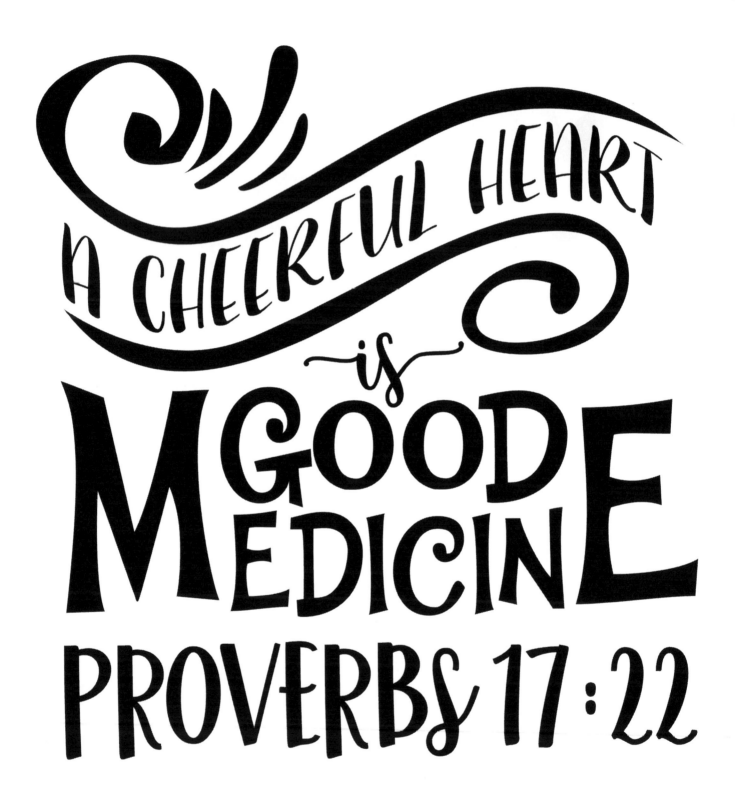

A CHEERFUL HEART is GOOD MEDICINE PROVERBS 17:22

He who COVERS HIS SINS WILL NOT *Prosper*

PROVERBS 28:13

SINS

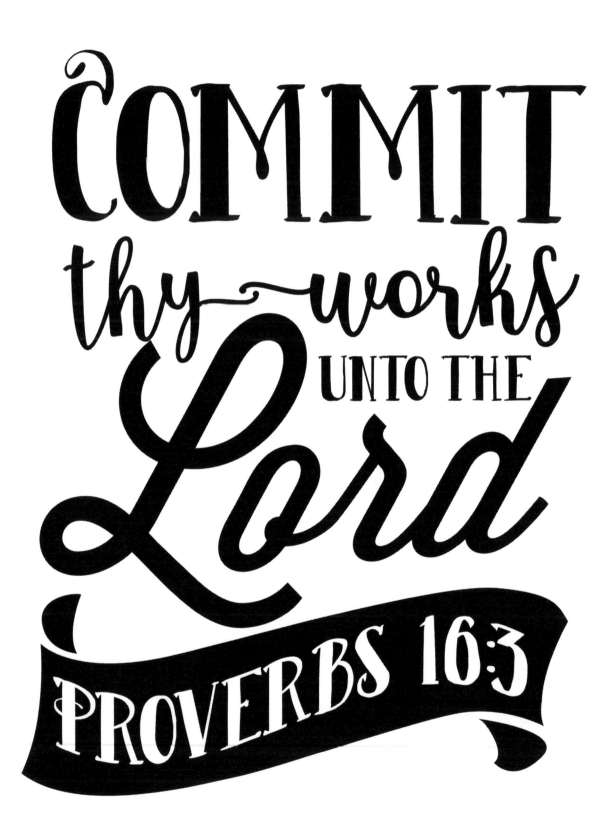

COMMIT thy ~ works UNTO THE Lord

PROVERBS 16:3

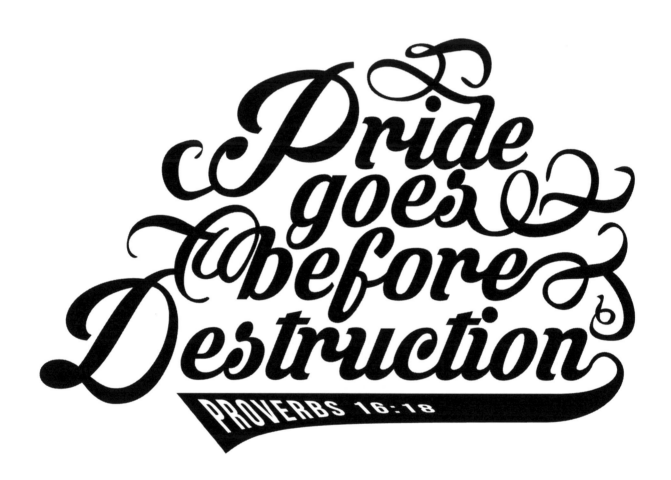

Pride goes before Destruction

PROVERBS 16:18

Pride goes before destruction

PROVERBS 16:18

HONOR THE LORD with your WEALTH

PROVERBS 3:9

THE PATH OF THE VIRTUOUS

LEADS

away from EVIL

PROVERBS 16:17

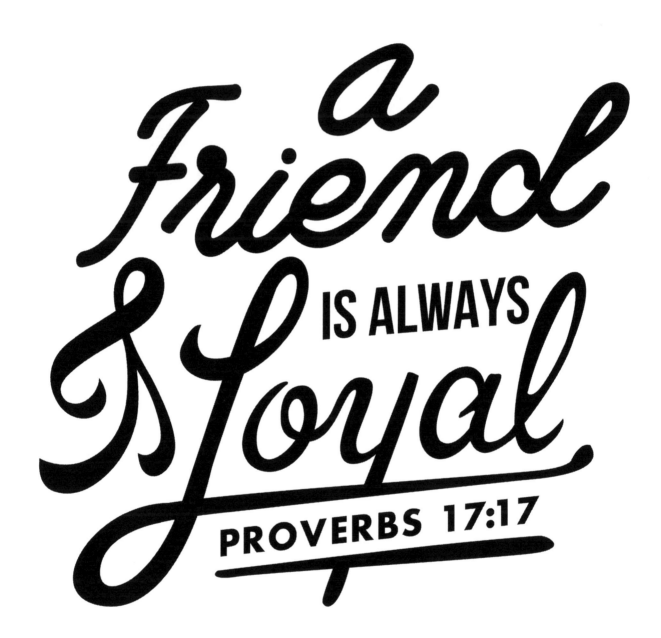

A friend IS ALWAYS Loyal

PROVERBS 17:17

Loyal

Do not
FORGET
my WORDS
or turn away
FROM THEM
Proverbs 4:5

FORGET

Rich & Poor have a common BOND: the LORD is the maker of them all

PROVERBS 22:2

STAY AWAY FROM A FOOLISH MAN

PROVERBS 14:7

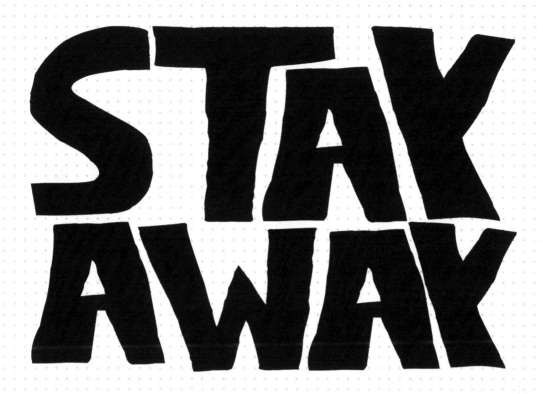

Blessed IS THE ONE WHO HEEDS WISDOM'S instruction

PROVERBS 29:18

WISDOM'S

MY CHILD, KEEP YOUR FATHER'S COMMANDMENT, AND DO NOT FORSAKE YOUR MOTHER'S TEACHING PROVERBS 6:20

FATHER'S

CHOICE SILVER
IS THE *tongue*
OF THE JUST;
THE
Heart
OF THE *wicked*
is of little worth
PROVERBS 10:20

Heart

THE RIGHTEOUS should choose his FRIENDS CAREFULLY, **W** FOR THE WAY OF THE **WICKED** leads them **ASTRAY** PROVERBS 12:26

WICKED

THE ONE WHO OPPRESSES THE POOR PERSON *insults his Maker,* BUT ONE WHO IS KIND TO THE NEEDY *Honors Him* PROVERBS 14:31

POOR PERSON

THE SOUL OF THE *unfaithful feeds on* VIOLENCE *Proverbs 13:2*

feeds on

A scoffer WHO IS REBUKED WILL ONLY HATE YOU; the wise, WHEN REBUKED, WILL LOVE YOU PROVERBS 9:8

THE FEAR OF THE
LORD
PROLONGS LIFE,
BUT THE YEARS OF THE
WICKED
WILL BE SHORT
PROVERBS 10:27

TRAIN THE
YOUNG
IN THE WAY
THEY SHOULD GO
PROVERBS 22:6

YOUNG

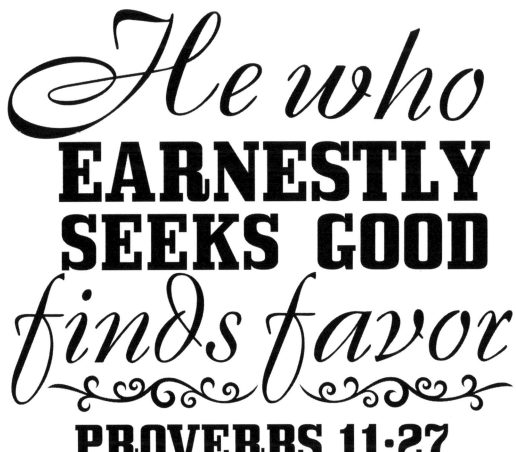

He who
EARNESTLY
SEEKS GOOD
finds favor
PROVERBS 11:27

He

JEALOUSY

is Rottenness

to the bones

PROVERBS 14:30

JEALOUSY

THE

prayer

OF THE

upright

IS HIS

delight

PROVERBS 15:8

BE SURE TO FOLLOW US ON SOCIAL MEDIA FOR THE LATEST NEWS, SNEAK PEEKS, & GIVEAWAYS

inspiredtograce

Inspired-to-Grace

@inspired2grace

ADD YOURSELF TO OUR MONTHLY NEWSLETTER FOR FREE DIGITAL DOWNLOADS AND DISCOUNT CODES

www.inspiredtograce.com/newsletter

CHECK OUT OUR OTHER BOOKS!

WWW.INSPIREDTOGRACE.COM

CHECK OUT OUR OTHER BOOKS!

WWW.INSPIREDTOGRACE.COM

CHECK OUT OUR OTHER BOOKS!

WWW.INSPIREDTOGRACE.COM

33447771R00056

Printed in Poland
by Amazon Fulfillment
Poland Sp. z o.o., Wrocław